# ARPA LLANERA (HOW TO PLAY)

A Beginners Guide To Mastering The Venezuelan Harp:Learn To Play With Step-By-Step Instructions:Your Path To Proficiency

**ETHA MOLINA**

Table of Contents

# CHAPTER ONE ................................ 7
## Greetings from Arpa Llanera ................................................ 7
Learn about the rich history of Arpa Llanera music. ........................ 7

# CHAPTER TWO .......................... 11
## Correct Posture and Hand Positioning ............................... 11
Basics of Music Theory: ... 11

# CHAPTER THREE ..................... 17
## An Introduction to Tablature and Sheet Music ..................... 17

Comprehending Musical Symbols and Terminology: ................................................... 17

CHAPTER FOUR ......................... 21

Creating Your Own Unique Musical Style ............................ 21

Adding Ornaments and Embellishments ................... 21

CHAPTER FIVE .......................... 25

Working with Other Musicians ................................ 25

Overview of Recording Software and Hardware .. 26

CHAPTER SIX ............................. 29

Preventing minor Problems and Repairs ............................. 29

Long-Term Storage and Climate Considerations: ..29

CHAPTER SEVEN ..................... 33

Participating in festivals and cultural gatherings ............... 33

Identifying and Overcoming Musical Plateaus: ............................. 33

Copyright 2024 Etha Molina

All rights reserved. Except for brief quotations included in critical reviews and certain other noncommercial uses allowed by copyright law, no part of this publication may be reproduced, distributed, or transmitted in any form or by any means, including photocopying, recording, or other electronic or mechanical methods, without the publisher's prior written permission.

**Disclaimer:** Etha Molina's personal knowledge and insight are the basis for this book's writing. The author has no connection to any organization, business, or person that is referenced in the book. The material offered should not be interpreted as professional advice; rather, it is only meant to be used for general informative reasons. Regarding specific concerns pertaining to playing an instrument, maintaining one, or any other topic addressed in this book, readers are urged to seek advice from qualified specialists or professionals. Any liability or responsibility for any loss or harm resulting from the use of the information provided herein is disclaimed by the author and publisher.

# CHAPTER ONE
## Greetings from Arpa Llanera

Welcome to the lively world of Arpa Llanera, where the mesmerizing sounds of the harp bring traditional Venezuelan music to life. Explore a musical trip that invites you to discover its distinct charm and expressive beauty as it combines history, culture, and rhythmic tunes.

### Learn about the rich history of Arpa Llanera music.

The soul of Venezuela is embodied in Arpa Llanera music, which is a cultural tapestry fashioned from the customs of the Llanos region. Learn about its rich history, its storytelling traditions, and the pulse of rhythm that gives it its unique character. Take in tunes that evoke the energy and tenacity of its people, enthralling listeners with every poignant note.

Recognize the harp's significance in Venezuelan traditional culture.

In Venezuelan culture, the harp is highly esteemed, acting not just as an instrument but also as a representation of national identity and legacy. Examine how its uplifting tones unite communities and inspire pride in their musical heritage throughout celebrations, rituals, and daily life.

## The advantages of mastering the Arpa Llanera

Gaining proficiency on the Arpa Llanera can lead to a journey of cultural and personal growth. It not only helps with musical proficiency but also with self-control, tolerance, and a greater understanding of Venezuelan customs. Take pleasure in producing music that inspires empathy and cuts across linguistic boundaries to give listeners a feeling of inclusion in the diverse range of Latin American music.

A synopsis of the parts and construction of the harp

With careful attention to detail, the Arpa Llanera is a work of art that produces a unique sound. Discover more about its sophisticated construction, flawlessly tuned strings, and the intricate system that enables accurate musical expression. Explore the creativity involved in its production and learn how the harp's distinctive resonance is produced by the harmony between each part.

### Motivational tales from well-known Arpa Llanera artists

Take a cue from the great Arpa Llanera musicians, whose commitment and passion have influenced the genre's history. Their tales shed light on the process of becoming proficient with this alluring instrument, providing knowledge about technique, performance, and the unwavering spirit that characterizes their musical journey. Learn how their talent has had an enduring impression on the world of Venezuelan music and how it continues to enthrall listeners around.

**Choosing the Correct Arpa Llanera:** Take into account aspects like size, string type, and craftsmanship before making your choice. Beginners may find a smaller harp simpler to manage, while durability and sound quality can be influenced by the wood and string type.

Whether you are more concerned with portability or classic sound qualities, choose a harp that you can play with comfort and that meets your artistic objectives.

**Knowing the Strings and Tuning of the Harp:** The Arpa Llanera usually has 32 strings, each of which has a distinct note and tension. Making melodic music requires an understanding of how these strings are tuned, which is frequently to diatonic scales. Using a tuning key, each string is adjusted to the proper pitch during tuning, ensuring that the sound produced by the harp is evenly distributed throughout its range.

# CHAPTER TWO
## Correct Posture and Hand Positioning

To play the Arpa Llanera well and without strain, proper posture and hand placement are crucial. With the harp resting securely against your shoulder, take an upright position. Naturally bending your hands over the strings, place your fingertips such that you can pluck or dampen the strings as needed. Maintaining this posture helps you avoid long-term physical discomfort while also improving your playing technique.

**Basics of Music Theory:** Learning the Arpa Llanera requires a basic understanding of music theory concepts like notes, scales, and rhythms. Discover how notes relate to string placements and how melodies are influenced by scales. Your ability to read sheet music, improvise, and interact with other musicians is enhanced by this

knowledge, which also improves your whole musical experience.

**Easy Warm-Up Exercises:** Stretch your fingers and become acquainted with the range of your harp before beginning to play any compositions. Start with easy scales and arpeggios to hone your finger dexterity and become acquainted with the structure of the harp. These exercises help you psychologically and physically prepare your hands, which will ensure a smooth and successful practice or performance session.

**Key Finger Methods and Plucking Styles:** Knowing keyfinger methods and plucking styles is the first step towards mastering the Arpa Llanera. It's essential to use techniques like thumb-under and finger-over to produce distinct, resonant tones. Tremolo and rasgueado are two examples of plucking approaches that require fine control over finger motions yet bring

depth and expression to your playing. Beginners can attain flexibility in their technique, guaranteeing that every note resonates with clarity and emotion, using focused practice and steady improvement.

**Acquiring Knowledge of Typical Arpa Llanera Rhythms:** The key to playing the Arpa Llanera is understanding its unique rhythms. From the vivacious Joropo to the melancholic Pasaje, every rhythm has a distinct personality and necessitates particular accents and rhythmic patterns. Beginners should begin by learning the fundamentals of rhythmic structures before working their way up to more complex versions. Players can acquire the innate sense of timing and groove necessary for a genuine performance by playing with a metronome and paying close attention to recordings.

**Practice Exercises for Skill Development:** Learning the Arpa Llanera

requires effective practice exercises. Technique drills, rhythmic exercises, and repertoire growth should be the main objectives of structured lessons. As skill increases, start with focused exercises that focus on difficult passages or techniques, and then progressively increase pace and complexity. As players develop muscle memory and hone their playing technique over time, consistency and patience are essential.

**Establishing a steady pace and Rhythm:** For a fluid Arpa Llanera performance, establishing a steady pace and rhythm is essential. To start, practice using a metronome to create a steady beat. As your comfort and control improve, progressively pick up the pace. To ensure smooth transitions between phrases and variations and continuous playing, pay close attention to rhythmic correctness. A player's innate sense of tempo can be developed via deliberate practice and focused listening, which improves musical expression and coherence.

**Advice for Increasing Finger Strength and Dexterity:** Learning the Arpa Llanera requires increasing finger strength and dexterity. To increase dexterity and accuracy, incorporate finger exercises like scales and arpeggios that focus on particular muscle groups. To progressively increase your strength, use training equipment like resistance bands or finger weights. Furthermore, playing energetic works with different rhythms and tempos tests finger dexterity and coordination, leading to increased control and diversity in performance.

# CHAPTER THREE

## An Introduction to Tablature and Sheet Music

Learning to play the arpa llanera requires the use of tablature and sheet music. While tablature offers a simplified depiction of finger placements on the strings, sheet music uses traditional staff notation to provide extensive directions on pitch, rhythm, and dynamics. Beginners who master both will be able to perform and interpret a variety of musical pieces, from modern compositions to well-known songs.

**Comprehending Musical Symbols and Terminology:** It is essential to comprehend musical symbols and terminology to traverse sheet music and tablature with ease. Notes pauses, clefs, and dynamics markings are examples of symbols that express pitch, duration, and expressiveness. Notation for volume and articulation includes staccato, pianissimo, and

forte. Beginners can interpret music on the arpa llanera more precisely and expressively if they are familiar with these components.

**Timing and Rhythm Reading:** Accurate rhythm reading is essential to preserving the coherence and flow of music. Players can comprehend the timing and length of each note or pause by learning rhythmic notation, which consists of quarter notes, eighth notes, rests, and their permutations. This ability is essential for accurately and authentically performing rhythmic llanera arpa genres like pasaje and joropo.

**Transposing Melodies for Different Keys:** Arpa Llanera players can modify music to fit different keys by transposing melodies without changing the original pitch relationships. Recognizing transposition entails moving each note of a composition up or down at a fixed interval. This ability comes in quite handy when it comes to matching the vocal ranges of singers or

accompanying other instruments in a variety of musical settings.

**Exercises for Sight-Reading:** Sight-reading exercises improve one's ability to quickly and accurately understand tablature and sheet music. Beginners can increase their ability to play new pieces fluently at first sight by practicing sight-reading regularly. This ability not only expedites learning but also develops self-assurance and flexibility when playing the arpa llanera and meeting new musical compositions.

### Acquiring Knowledge of Customary Arpa Llanera Songs

Choose straightforward songs that you can relate to to begin learning traditional Arpa Llanera melodies. Divide each tune into digestible chunks, practice them gently, and then progressively pick up the speed. Make sure that every note is accurate by paying great attention to the rhythm and phrasing that characterize Arpa Llanera music. To aid in your study, use recordings or

sheet music, paying close attention to how each melody is expressed and feels authentically.

## Examining Modifications and Adaptation Methods

Analyze existing melodies before diving into variations and improvisation. Try modifying the original song's rhythms, adding ornaments, or adjusting the harmonies while keeping the core melody. Start by improvising brief sentences, then as your confidence increases, work your way up to longer improvisations. Use Arpa Llanera-specific scales, trills, and arpeggios to improve your improvisational abilities and produce engaging performances.

# CHAPTER FOUR

## Creating Your Own Unique Musical Style

Acquiring an awareness of your taste and influences in music is the first step towards creating your own style. Examine a variety of Arpa Llanera artists and note the aspects you find appealing. Try out a variety of tempos, dynamics, and rhythmic patterns to see what most suits your musical style. Use these components in your practice sessions regularly to hone your approach by ongoing experimentation and introspection.

## Adding Ornaments and Embellishments

Use the ornaments and flourishes that are typical of Arpa Llanera music to improve your performance. To add more expression and authenticity to your melodies, start by learning basic ornaments like turns, mordents, and trills. Then, gradually incorporate them into your compositions. At first, practice these ornaments gently, making sure that every performance is

clear and precise. Try varying the location and timing of your notes to improve the emotional impact of your compositions and produce a more complex and nuanced performance.

### Using the Arpa Llanera to Explore Various Musical Genres

Play the Arpa Llanera to explore a variety of musical styles and broaden your repertoire. Choose genres that you are interested in first, such as folk, classical, or modern styles. To fit the qualities of each genre, modify conventional Arpa Llanera approaches by experimenting with alternative rhythms, harmonies, and instrumentation. Expand your creative potential and musical versatility by working with artists from other backgrounds and gaining fresh viewpoints. This is possible with the Arpa Llanera.

**Overcoming Nerves and Stage Fright:** To overcome nervousness and stage fright, begin by practicing relaxation methods like deep breathing and visualizing. Expose oneself to public performance on a gradual basis, starting with friends or small crowds. Remind yourself that feeling nervous is normal and turn your attention to the music instead of your worry. Over time, you can lessen stage fear and increase confidence with regular exposure and encouraging self-talk.

**Appropriate Preparation for Public Performances:** A comprehensive rehearsal process guarantees that you are completely familiar with your pieces. Practice with the same instrument and wearing the same clothes under circumstances that are close to the real event. Make a list of the necessities, such as sheet music and extras. Get there early to get a feel for the space and to fully warm up. Being organized allows you to reduce anxiety and concentrate on giving a professional performance.

**Effective Techniques for Engaging Your Audience:** Getting your audience involved improves their experience and elevates your presentation. To start a conversation, keep your eyes open and grin sincere. Adjust the tempo and dynamics to keep the audience interested. To set the scene, introduce the pieces with succinct explanations or stories. React favorably to compliments and praise. Everyone engaged will find your presentation unique and entertaining if you actively include your audience.

# CHAPTER FIVE

## Working with Other Musicians

Respect and open communication are the cornerstones of a successful working relationship. Recognize the roles and strengths of each musician in the group. Practice in unison to ensure that timing, dynamics, and interpretation are in sync. To create a cohesive sound, be willing to compromise and stay receptive to input.

Respect one another's compositional ideas and efforts to create a positive and effective rehearsal environment. You can produce vibrant, well-coordinated concerts that highlight the individual talents of each musician by working well together.

**Managing Performance Errors with Grace:** Errors happen during performances; how you respond to them defines your professionalism. Stay on task and try not to think back on mistakes. If you make a mistake, just

keep playing and don't lose your cool. Discover methods such as improvisation to recuperate with ease. After the performance, evaluate what went well and what still needs work without passing judgment on yourself. By accepting errors as teaching moments and maintaining composure, you show maturity and perseverance in your artistic endeavors.

## Overview of Recording Software and Hardware

You'll need some basic gear, like headphones, an audio interface, and a microphone, to start recording your song. For recording and editing, software like digital audio workstations (DAWs) like Logic Pro or Pro Tools is necessary. To get clear audio, set up your equipment in a place where there is little background noise.

### Advice on Producing Excellent Audio Recordings

The optimal sound from your harp can be captured by carefully positioning your

microphone. Try a variety of positions until you achieve the ideal harmony between warmth and clarity. To lessen plosive noises, use pop filters, and reduce room reverberation, think about installing foam panels or other acoustic treatments. To maintain audio quality, record in uncompressed formats such as WAV.

### Enhancing and Editing Your Audio

After recording, edit and improve your recordings with your DAW. To improve the quality of your sound, remove extraneous sounds or errors, change the loudness, and add effects like equalization or reverb. Utilize automation capabilities to produce a professional final mix and to minimize noise variations in volume.

**Important Care and Maintenance Advice:** Frequent maintenance is essential to maintaining the best possible condition for your Arpa Llanera. After every session, wipe down the body and strings to get rid of any dust or grease that can have an impact on the sound quality. To

stop loose screws or levers from compromising tuning stability, check and tighten them. To prevent warping or breaking, keep the harp in a stable place away from intense sunshine or high humidity.

**Tuning and Restringing Your Harp:** A pleasant sound depends on maintaining correct tuning. Tune each string to the correct pitch regularly with a dependable electronic tuner. To keep the harp in tune and preserve tension, replace a string at a time when restringing. To ensure the best performance, use the string types and tensions recommended by the manufacturer for your Arpa Llanera.

# CHAPTER SIX

## Preventing minor Problems and Repairs

Major repairs can be avoided by being aware of minor problems like buzzing strings or sticky levers. Regularly check the harp for wear or damage, and take quick care of any small problems. Steer clear of extreme string tension and abrupt temperature swings to avoid causing structural damage. For intricate repairs, seek the advice of a trained specialist to preserve the durability and integrity of the harp.

**Long-Term Storage and Climate Considerations:** When your Arpa Llanera is not in use, it is important to store it properly to keep it safe. To protect the harp from dust and unintentional impacts, keep it inside a cushioned case or cover. Select a storage area with consistent humidity and temperature to avoid

wood contraction or expansion, which over time can compromise structural integrity and tuning.

**Suggested Add-ons and Equipment:** Investing in high-quality add-ons will improve your harp's sound and lifespan. Think about adding extras like a tuning key for easy changes, a padded bench for pleasant practice sessions, and a humidity gauge to keep an eye on storage conditions. The harp's finish and sound quality can be preserved by using specialist polishes and gentle cleaning cloths.

## The Arpa Llanera's historical context and evolutionary history

Discover the fascinating history of the Arpa Llanera by following its ancestors from native influences and colonial times to its current incarnations. Recognize how the instrument has changed over centuries, adjusting to technological breakthroughs and cultural changes while maintaining its unique tone and importance in Venezuelan music.

## Regional differences in the music of Arpa Llanera

Explore the various regional variations of Arpa Llanera music throughout Venezuela, ranging from the Andean highlands to the Apure plains. Discover how the distinct topography, customs, and ethnic influences of each area have influenced the music, leading to variances in rhythm, melody, and lyrical themes that mirror local identities and histories.

## Arpa Llanera's effects on Venezuelan society

Examine the enormous cultural effects of the Arpa Llanera on Venezuelan society, including how it affects national pride and identity as well as how it functions in customary events and celebrations. Recognize how this instrument has provided generations of Venezuelans with entertainment as well as a symbol of solidarity, resiliency, and cultural legacy.renowned Arpa Llanera musicians and composers

Meet the extraordinary individuals who have influenced Arpa Llanera's history, from avant-garde composers who created beloved songs to master musicians whose concerts enthralled audiences across the country. Examine how they have helped to broaden Arpa Llanera's repertory and push the instrument's limits both individually and in groups.

# CHAPTER SEVEN
## Participating in festivals and cultural gatherings

Take in the colorful ambiance of Venezuela's Arpa Llanera festivals and cultural activities. Discover for yourself the delight of in-person events, seminars, and contests honoring the instrument's function in maintaining cultural customs and promoting a sense of community.

**Identifying and Overcoming Musical Plateaus:** This chapter will teach you how to recognize when you've reached a point in your arpa llanera journey where you feel like you're not making any progress at all. By acknowledging these stages as normal components of skill growth, you can modify your practice strategies and look for fresh obstacles to advance to the next level.

**Techniques for Retaining Inspiration and Motivation:** Being enthusiastic is essential

to learning the arpa llanera. Learn useful techniques including branching out into different musical genres, establishing modest, attainable goals, and interacting with other musicians. These methods will sustain your enthusiasm and encourage ongoing development.

**Setting Achievable Objectives and Monitoring Your Progress**: Discover how to create precise, attainable goals that are in line with your ambitions and ability level. You can successfully track your progress by splitting down major milestones into smaller, more doable activities. This technique guarantees consistent improvement in your arpa llanera abilities in addition to giving you a confidence boost.

**Seeking Advice from Mentors and Teachers:** Make use of the knowledge that mentors and teachers possess; they can offer insightful commentary and tailored criticism. Their experience can provide perspective, and

correct technique, and inspire new musical ideas, increasing your learning curve—whether through official instruction or casual guidance.

**Handling Moments of Frustration and Self-Doubt:** Resolving these feelings is crucial to staying motivated. Discover doable solutions to these problems, like taking pauses, concentrating on minor victories, and maintaining an optimistic outlook. You will be able to overcome obstacles and come out stronger in your arpa llanera journey if you possess this resilience.

**Taking Care of Common Issues Beginners Face:** Finger coordination, comprehending musical notation, and continuing regular practice are some of the common issues that beginners face. To address these problems, techniques should be broken down into manageable steps, practiced frequently with patience, and specific obstacles should be

overcome by consulting teachers or internet resources.

Managing Physical Pain During Playing: Incorrect posture, stiff muscles, or repetitive strain can all cause physical pain during harp playing. It's critical to practice with good posture, take regular pauses, and stretch your muscles to release tension. Additionally, you may reduce strain and guarantee comfortable playing by adjusting the harp's height and seat position.

**Handling Practice and Other Commitments:** Time management skills are necessary to strike a balance between harp practice and other obligations. Make a practice regimen that works with your everyday schedule and allot a specific amount of time each day for practice. Set priorities and set aside time for scales, repertoire, and technical exercises so that you may practice them consistently without ignoring other obligations.

Advice for Considering Money When Playing the Harp: When playing the harp, you'll need to budget for things like buying or renting an instrument, maintaining it, and paying extra for classes or sheet music. To control costs while advancing in their musical journey, beginners should investigate choices such as renting a harp initially to lower upfront costs, budgeting for maintenance and accessories, and studying reasonably priced lesson options or online resources.

Comprehensive Responses to Frequently Asked Questions: This section offers in-depth responses to frequently asked questions from novice harpists on a variety of subjects, including upkeep of the instrument, tuning methods, repertoire selection, hiring qualified instructors, and being involved in musical communities. It dispels questions about honing technique, getting over stage fright, and moving from beginning to intermediate proficiency, guaranteeing a

comprehensive comprehension of the instrument and its subtleties.

The journey through the complexities of learning the harp is shown in the final ARPA LLANERA (HOW TO PLAY) as more than just a technical struggle; it becomes a testimonial to dedication and affection for this classic Venezuelan instrument. We've covered a lot of ground in this tutorial, from learning the subtle art of string plucking to comprehending the rich history of music ingrained in every note.

This book sought to foster a profound understanding of the cultural value of the arpa llanera, going beyond technical proficiency. It serves as a bridge to connect with the lyrical rhythms and stories of Venezuelan folklore as well as a tool for musicianship. Every chapter explored the emotional depth necessary to accurately capture the spirit of this song in addition to the technical aspects of performing.

As we come to the end, keep in mind that learning the arpa llanera is a continuous process. It calls for endurance, patience, and a deep regard for the customs that have molded its melodies over many centuries. The key is to embrace the special fusion of technical accuracy and creative expression that characterizes this instrument, regardless of your level of experience—whether you're a novice learning the fundamentals or an accomplished player looking to improve.

Going forward, follow your enthusiasm for the arpa llanera to direct your musical exploration, practice with purpose, and keep exploring. Allow every note to reverberate not just through the strings but also through the rich cultural background that envelops this exquisite instrument. I hope that this guide will be a helpful ally in your musical journey, encouraging you to explore new depths, showcase your originality, and spread the enduring melodies of the arpa llanera around the globe.

To sum up, may the music you compose serve as an ode to custom, an illustration of your commitment, and a reminder of the area Llanera's timeless ability to captivate listeners.

www.ingramcontent.com/pod-product-compliance
Lightning Source LLC
Chambersburg PA
CBHW072021230526
45479CB00008B/319